The Tiny Book of Tiny Stories

1 volume 2 3

DEY ST.
AN IMPRINT OF
WILLIAM MORROW *PUBLISHERS*

Manufactured in China.

HarperCollins books may be purchased for educational, business, or sales promotional
use. For information, please e-mail the Special Markets Department at
SPsales@harpercollins.com.

FIRST EDITION

ISBN 978-0-06-212163-9

18 19 20 SCP 10 9 8 7 6 5

tiny stories

2

"The universe is not made of atoms;
it's made of ⌃*tiny* stories."

-Muriel Rukeyser & wirrow

re we RECording? RegularJOE here!
onight we find ourselves deep in the
cret hideaway of none other than the
ellar starter of our Tiny Stories sensation:

irrow! Thanks for having us, man!

nice to have you here, joe.
don't touch anything...
it's all very expensive.

wirrow, countless tiny story tellers
ve been contributing to your collaboration,
d one of the questions they often ask is,
st exactly how long IS a tiny story?
re to comment?

it's as long as a piece of string.
a really tiny piece of string that
can stretch out from your pillow
to this forest, weaving through
mountains on the way and birds
perch on it and sing!

ee...

ell folks, contribute your new
y texts and drawings to
RECord.org/TinyStories3

Thanks again <3

LIT
RECORD

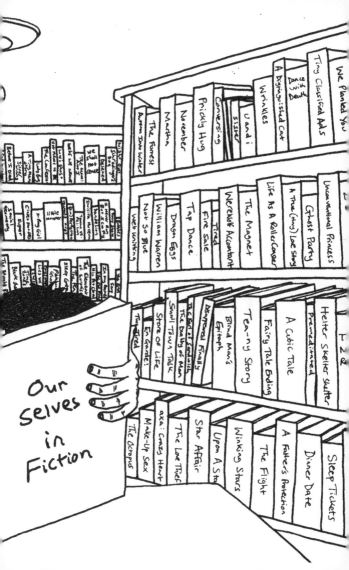

Her spiral put me into a hypnotic trance...

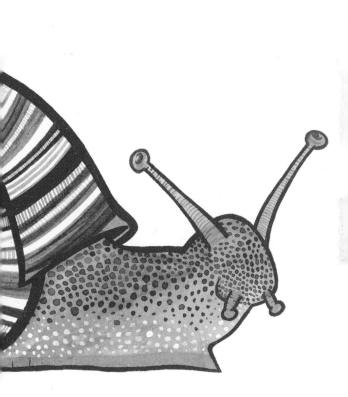

when i woke up my house was empty.

Your kisses are snowflakes:

each one is unique.

They land on me,

before they melt away

and leave me cold.

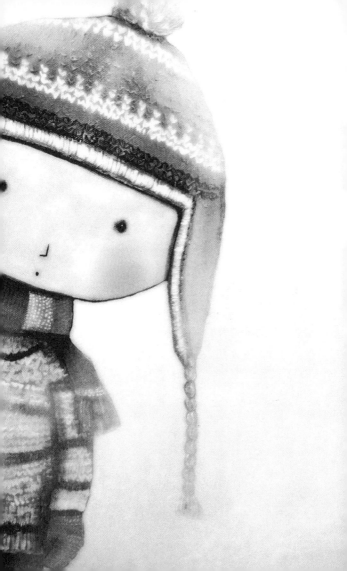

Goodnight sweet princes
and princesses.

May flights of angels
with umbrellas

shield your sacred heads from rain.

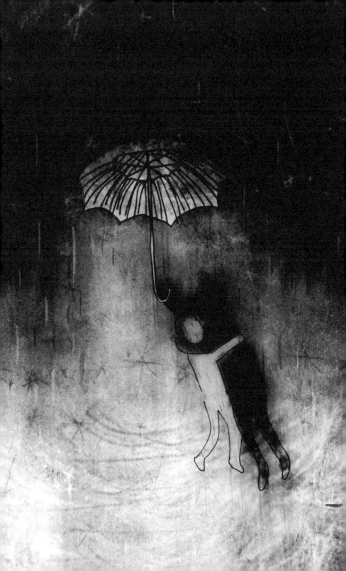

Her well-worn habit was
beginning to fray.

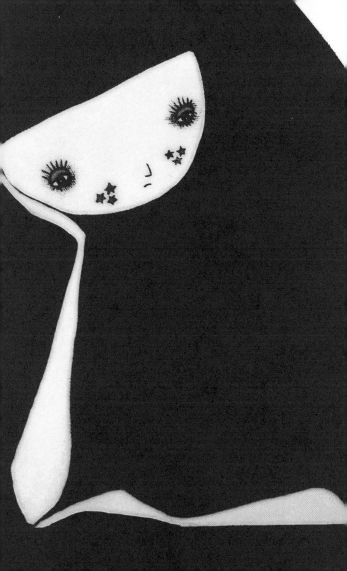

It was almost late November.

I decided to live in a tree,
and you came to visit me.

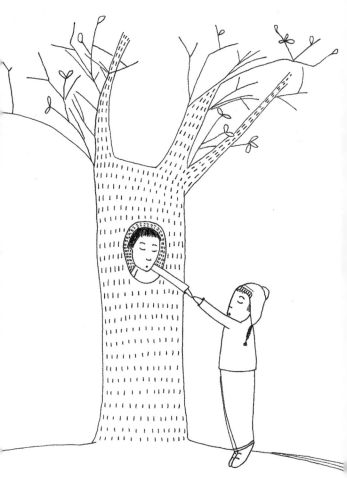

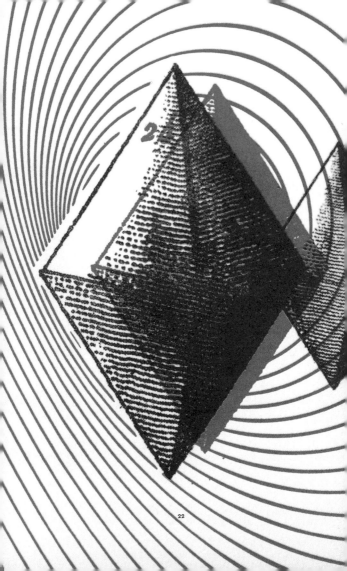

I'm tired

of being tired

of being tired

of being.

the

INVISIBLE MUSEUM

of

IMAGINARY ARTEFACTS

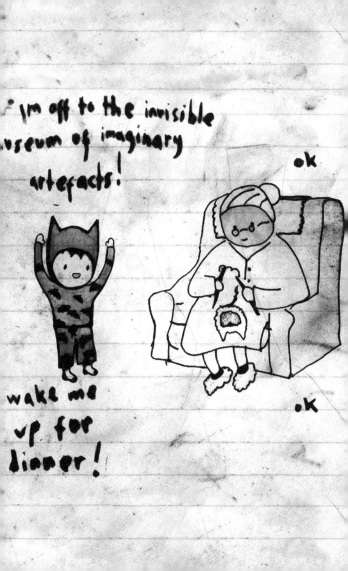

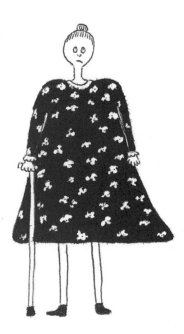

I am Gretel. I am always
inside my apartment.

Sometimes I throw water balloons
out my window, just to be noticed.

I just need some time away

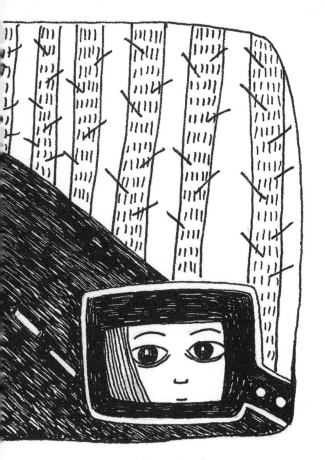

to remember why I stay.

I found life's loophole.

Now I get away with everything.

She read his letter again &
again 'til she found herself
afloat among the stars.

With a well-paying job

and a stable position

the call of the wild

was never an option.

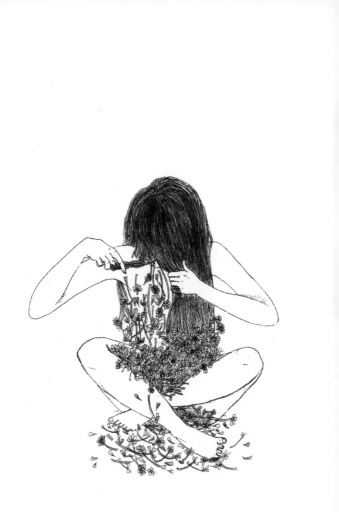

oh god something's
gone terribly wrong...
close the curtain

When Mr. Fox comes to visit,

though only if he's properly fed,

Mom lets him read me a story

and put me down to bed.

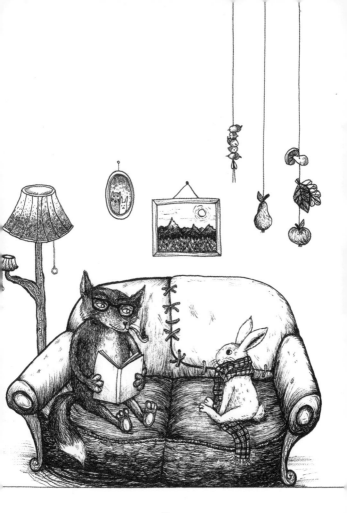

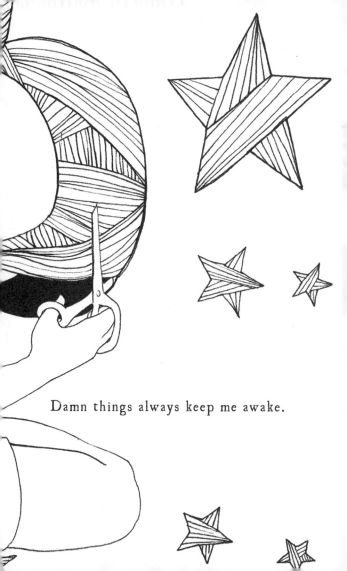

Damn things always keep me awake.

Weathered wandering wayfarers
watched wickedly whiskered
William Warren whittle wonders
with withering wood while warring
with wild whirling winds.

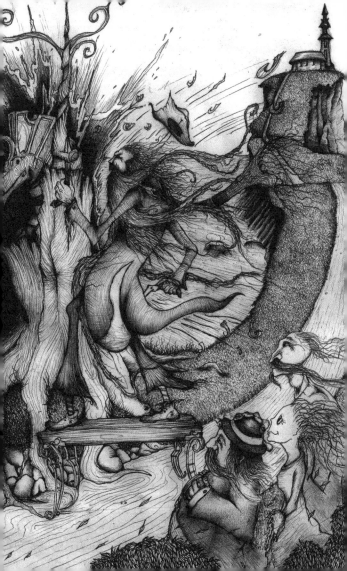

IMA STRANGE

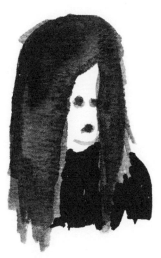

HER NAME WAS IMA STRANGE

IMA FOR HER MOTHER'S MOTHER
AND STRANGE FOR HER DAD.
SADLY SHE WASN'T VERY
STRANGE AT ALL.

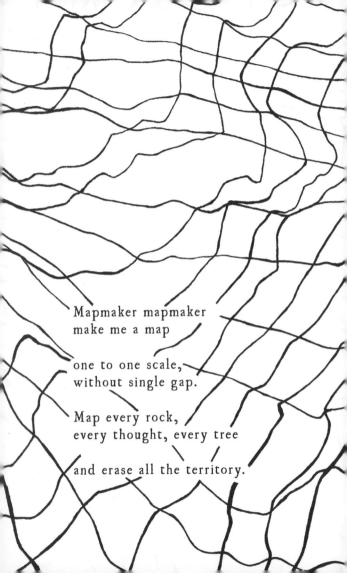

Mapmaker mapmaker
make me a map

one to one scale,
without single gap.

Map every rock,
every thought, every tree

and erase all the territory.

This is the saddest, most depressing music i've ever heard.

It makes me so happy.

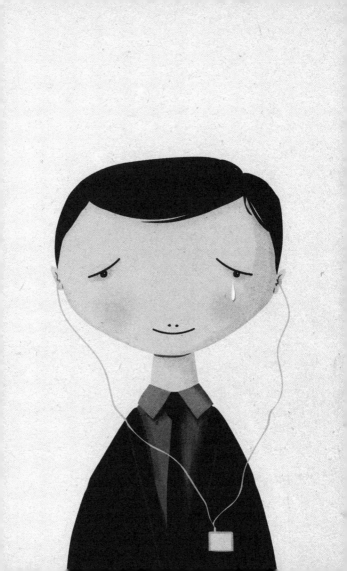

Once upon
a dream
in a blanket
of night sky
you asked me
to tell you a story
which began with
us holding hands.

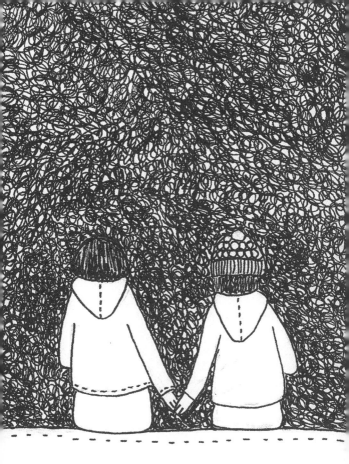

We agreed from the start:

All mood, no message.

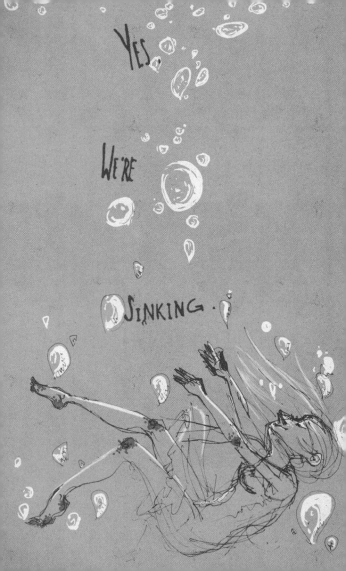

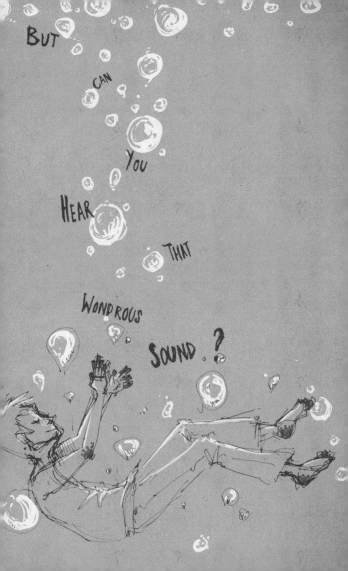

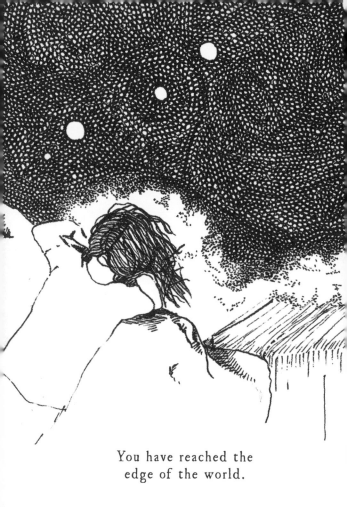

You have reached the
edge of the world.

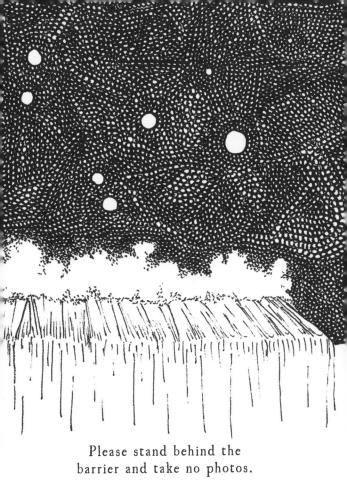

Please stand behind the
barrier and take no photos.

more messages af

r these messages.

Life and Death both took a break,

weary from their burdensome roles.

Nobody lived or died that day.

And when the day is done

I will follow you into the sun.

After you died I realized that
I never really liked hunting.

I just liked hanging out with you.

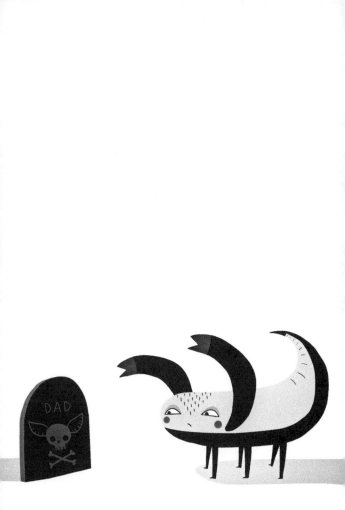

I lost you

when you left me

to find yourself.

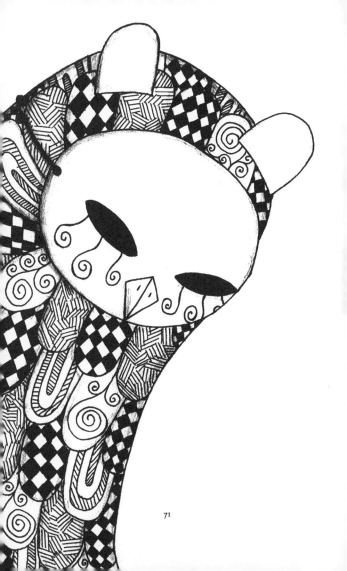

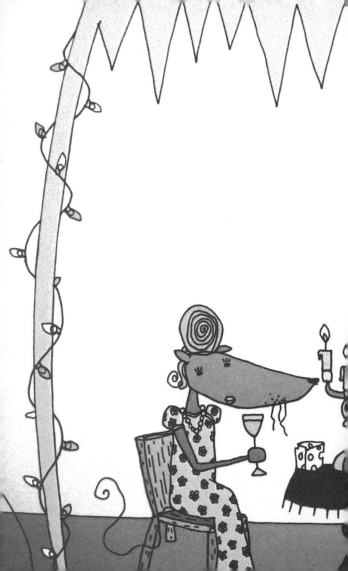

Savage mice overran
Mallory's home until she
built a better mousetrap
and attracted a more
elegant class of rodent.

As my story came to a
close I realized that I was
the villain all along.

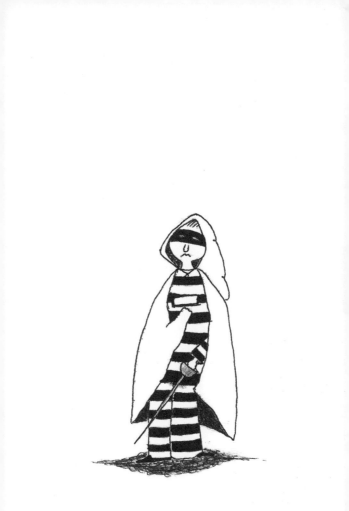

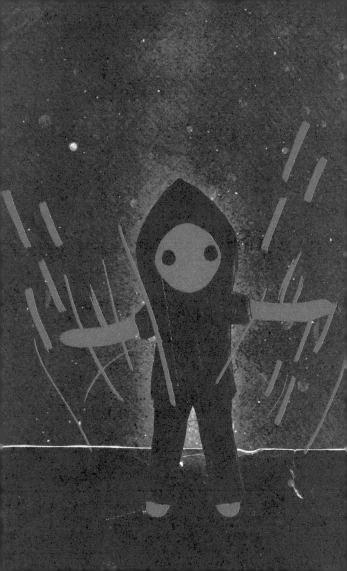

i stood and watched
the final sunset as the
world was ending.
light that once would fall
was now ascending.

The right shoe left, knowing
that the left shoe was right.

Tell no one about this cape.

He thought of all the
different ways to make it
look like an accident.

One last time I look around...

as I am lifted off this ground

for good.

Hidden well

beneath every shell

is a propeller for galactic travel.

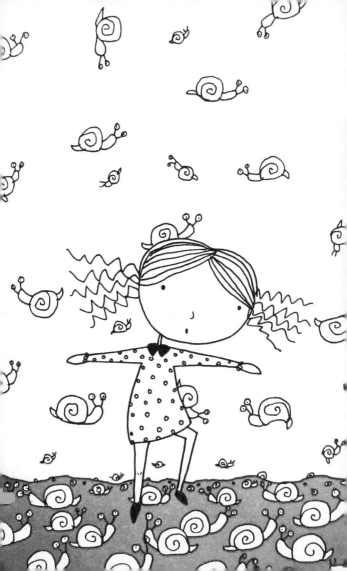

Arise, little one...

fellow Reaper of Souls.

Now let us prey.

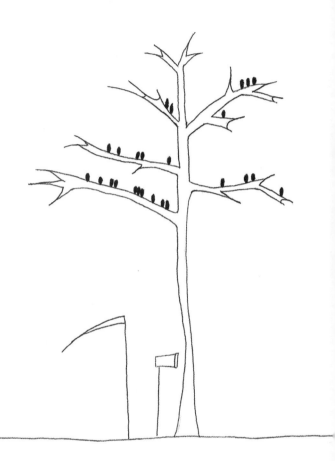

No one was even aware of its existence, but when it sounded out

we all knew...

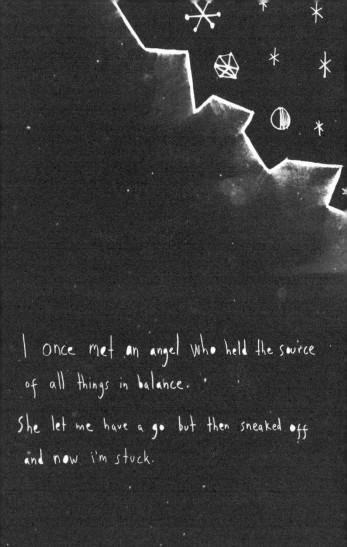

I once met an angel who held the source
of all things in balance.
She let me have a go but then sneaked off
and now i'm stuck.

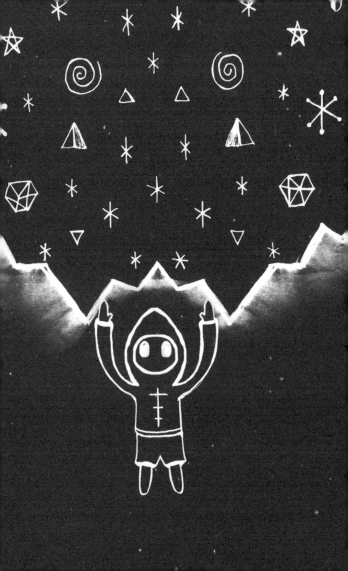

He imagined a wonderful world of possibilities outside the house...

but never checked, just in case.

THE DRAGON EGG

i was having a day nap and
i had a dream that you
bought me a dragon EGG
and i woke up and said where's
my dragon egg? and you
were like What Dragon egg?!
and i slowly remembered and
said OH, nothing... and felt stupid

Ambiguity lived in a place

with some people

who did some things.

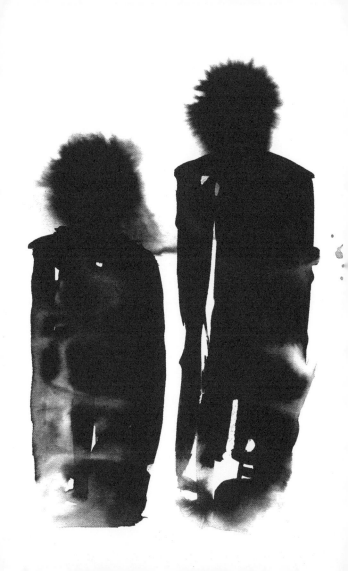

He felt a little sheepish,
but it was cold out there.

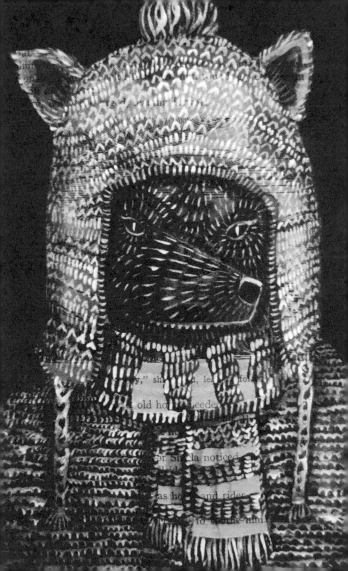

Now the old house is
soft and sinking;

only the field mice call it home.

But every once in a
while, she returns

and cares for the wildflowers.

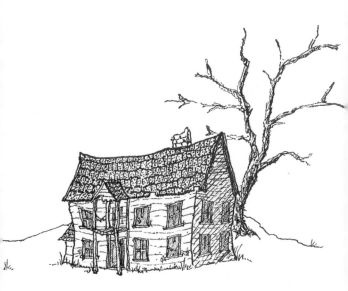

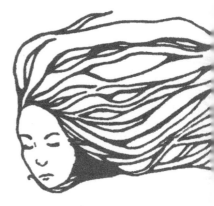

She came with a face and
a name but no soul.

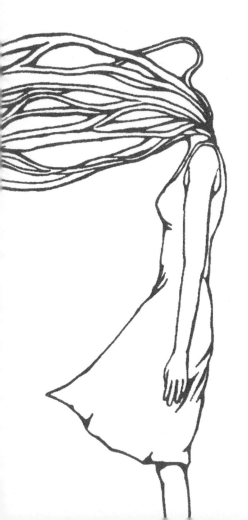

i came here on a dream
but when the dream was over
i was left behind.

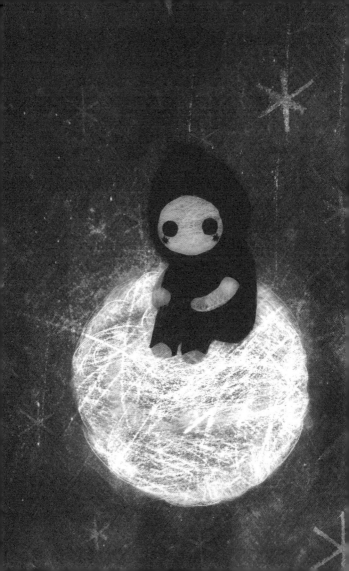

There are some things
you should know.

I don't know what they are.

But they're out there.

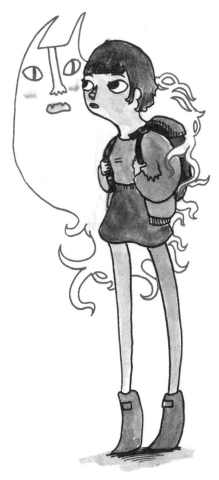

He drew all
the curtains,
so as to not let
Darkness in.

But Darkness
was already
hiding, waiting
with a grin.

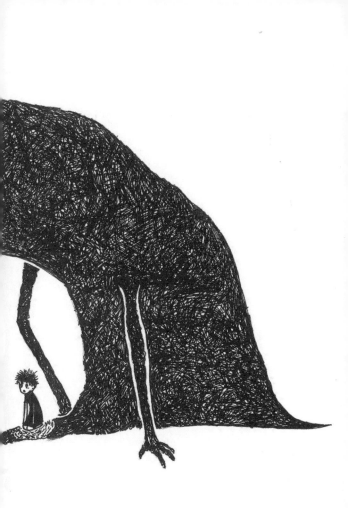

III

Dear world behind me:

I know you are an infinite hive
of possibilities endlessly coming
alive that will sneakily snap back
if I try to catch you in the act.

So I'm not going to!

But just know...
that I'm on to you.

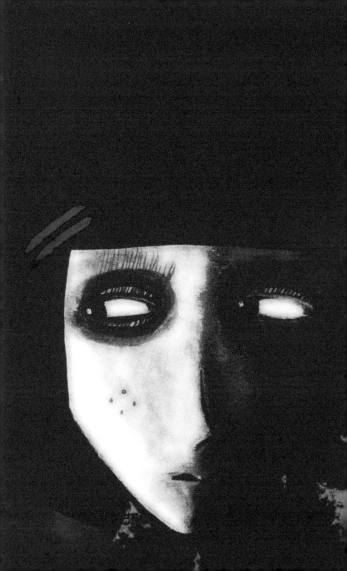

The creature only ventured out at dawn, when the world was quiet

and at its most forgiving.

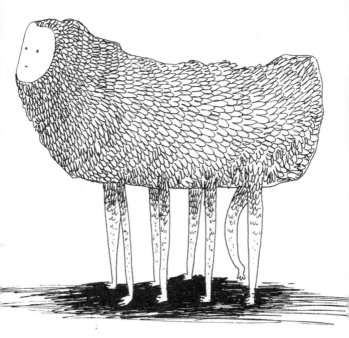

And in the morning

they shook their pillows

violently, hoping

all the dreams they lost

that night would tumble out.

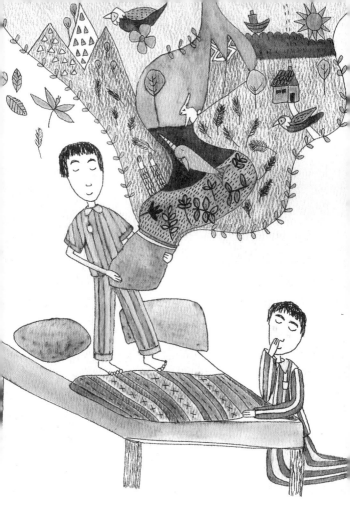

For years afterward he
told the story, but only the
children believed him.

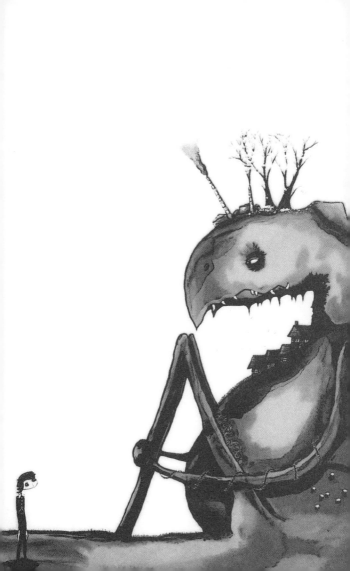

Your heart has a little empty
corner. You won't even know
I'm there — I'll be very quiet.

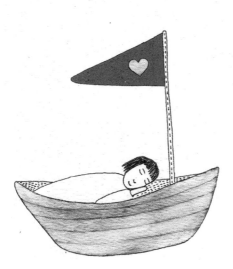

And so they linger together until there is no more music to be made.

RESOURCES:

p.	contributor	record no.

04-05	RegularJOE, wirrow	
06-07	yes-you-am, Unusual Suspect	766048, 740479
08-09	swimmingrabbit, lauramofli	793722, 724148
10-11	wirrow	584750
12-13	wirrow, stabbytuna	713473, 673543
14-15	blunderingandfrightening, sojushots	743174, 698810
16-17	wirrow	592898, 593751
18-19	sojushots	733765
20-21	mirtle	572119
22-23	chelseyscheffe, marke	112012, 736462
24-25	wirrow	351245
26-27	Inger, byshaike	698326, 669748
28-29	eaneikciv, mirtle	738710, 739753
30-31	wirrow, paperlilies	786755, 787002
32-33	Metaphorest, TheSerpentTheCharmer	766292, 754573
34-35	DianeFT, stellarNELR	757952, 748651
36	mixedtapes, Jazminny	760812, 581943
37	LifeAboveTheWaterline, SnickerSnack	768044, 551448
38-39	mprather75, aamanddacc	748005, 614520
40-41	wirrow	695735
42-43	DianeFT, gemeinesHaschel	588110, 489520
44-45	cacheth	750943

p.	contributor	record no.

p.	contributor	record no.
46-47	Wicked Goblin King	640677
48-49	walkerwt	632157
50-51	Marke, wirrow,	755098, 755483,
	cacheth	755545
52-53	wirrow, Kubi	803017, 764505
54-55	mirtle	692608
56-57	fryclad	774661
58-59	eaneikciv, chopsticksroad	377596, 582730
60-61	wirrow, imogenc	753633, 766568
62-63	Michal, ChristineNaderer	752294, 764789
64-65	DianeFT, mirtle	776480, 419881
66-67	wirrow, Sean Ono Lennon	753276, 773463
68-69	sarahgoodreau	740374
70-71	Metaphorest, Quincyyuzelim2012	784306, 652720
72-73	sojushots, Symbiote	751842, 748467
74-75	Malicore, Inger	743683, 753006
76-77	wirrow	762856
78-79	Joab Nevo, kittypimms,	749527, 753959,
	crane-crafter	767049
80-81	hannakong	708597
82-83	Kubi	766604
84-85	LifeAboveTheWaterline, mirtle	777032, 714147

p.	contributor	record no.

p.	contributor	record no.
86-87	blbest, sojushots	793370, 750505
88-89	wirrow, Inger	803023, 750973
90-91	wirrow, cacheth	255794, 458938
92-93	wirrow	760253
94-95	bloemday, quesadia	90692, 147157
96-97	wirrow	522820
98-99	franniewilliams, LydiaSaskia, Emma Conner	777606, 697628, 743004
100-101	beinglydia, sojushots	794309, 741957
102-103	meaganmoore	689264
104-105	jaaahnell, nomadicrobot	778948, 729552
106-107	wirrow	766561
108-109	maddyvian	772499
110-111	fleurdelys, wirrow, hopiamanipopcorn	272926, 803033, 423881
112-113	wirrow, sojushots	444597, 764031
114-115	Kubi, rewfoe	796153, 751639
116-117	thedustdancestoo, mirtle	774915, 781420
118-119	meaganmoore, sojushots	714412, 662138
120-121	janetfelts, mirtle	730864, 584858
122-123	meaganmoore	682679
ends	wirrow	753276

ABOUT HITRECORD

hitRECord is the open-collaborative production company founded and directed by actor and artist Joseph Gordon-Levitt. We create and develop art and media collectively using our website where anyone with an internet connection can upload their records, download and remix others' records, and work on projects together. When the results of our work and play are produced and make money, hitRECord splits the profits 50/50 with everybody who contributed to the final production.

Thanks again <3

THE TINY BOOK OF TINY STORIES
volume 2

Original Concept & Creative Direction by wirrow
Directed by Joseph Gordon-Levitt
Produced by Jared Geller
Creative Direction, Layout & Design by Marke Johnson